After Perestroika

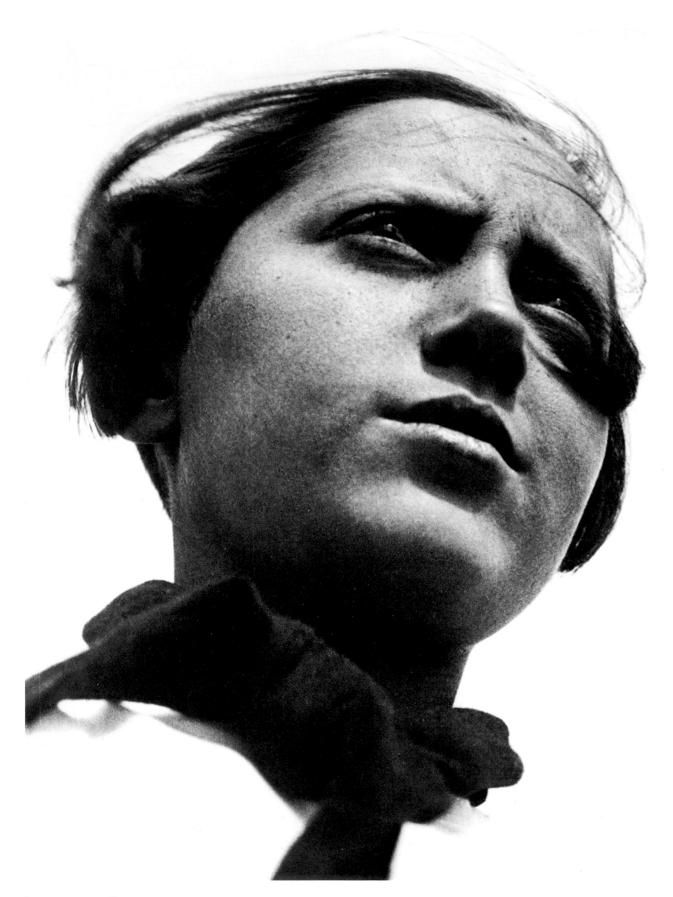

ALEKSANDR RODCHENKO
Young Pioneer Girl, 1930. Black-and-white photograph, reprint from a vintage negative, 11 × 8½ inches

AFTER PERESTROIKA: KITCHENMAIDS OR STATESWOMEN

Margarita Tupitsyn, Guest Curator

Essays by Margarita Tupitsyn and Martha Rosler

A traveling exhibition organized and circulated by
Independent Curators Incorporated, New York

ITINERARY

1 August to 3 October 1993
Centre International d'Art Contemporain de Montréal
(part of Les Cents jours d'art contemporain de Montréal)
Montréal, Québec, Canada

6 November to 31 December 1993
The Picker Art Gallery
Colgate University
Hamilton, New York

12 February to 27 March 1994
DePree Art Center and Gallery
Hope College
Holland, Michigan

18 April to 11 June 1994
Western Gallery
Western Washington University
Bellingham, Washington

15 September to 23 October 1994
Iris and B. Gerald Cantor Art Gallery
College of the Holy Cross
Worcester, Massachusetts

The exhibition, tour, and catalogue are made possible, in part, by a grant from
the National Endowment for the Arts, a Federal agency, and contributions from
the ICI Exhibition Patrons Circle and the ICI International Associates.

Lenders

Richard Ekstract

Elena Elagina

Ronald Feldman Fine Arts, New York

Galerie Johan Jonker, Amsterdam

Paul Judelson Arts, New York

Phyllis Kind Gallery, New York

Svetlana Kopystiansky

Krings-Ernst Galerie, Cologne

Raymond J. Learsy

Ludwig Forum für Internationale Kunst, Aachen

Igor Makarevich

Andrei Roiter

Maria Serebriakova

John Stewart

Oleg Vassilyev

James Wagman and Anne Landsman

Acknowledgments

After Perestroika: Kitchenmaids or Stateswomen opens its tour this summer as we learn of daily shifts and changes in the political and economic situation in countries which were only recently part of the Soviet Union. The art in this exhibition especially examines and comments on aspects of women's lives in Russia, and in other parts of the former Soviet Union, that have been neglected in Western media coverage of recent events there. I hope that, as it tours, *After Perestroika* will provide a forum for observation and discussion, and that the art it contains will be enjoyed for its formal and aesthetic qualities as well as for the political and societal insights it provides.

I am most grateful to ICI's guest curator, Margarita Tupitsyn, for the thoughtful selections she has made for this exhibition and for her essay which will introduce many of the artists in this exhibition to a new audience. Martha Rosler's essay, based on her recent participation in an exchange between Rutgers University and the Russian Union of Art Photographers, extends our knowledge of current Russian cultural attitudes and the socio-political climate for women and artists. Her contribution to this project has been invaluable.

Once again, ICI's excellent staff—Judith Olch Richards, Jack Coyle, Lyn Freeman, Anne Longnecker, Alyssa Sachar, and Nicole Fritz—has guided a complex project from initial concept to the handsome reality of a fine exhibition. I thank each one of them for the particular skills and abilities that they have brought to the task. I would also like to thank intern Erika Wan-Ling Chang for the assistance she has provided.

ICI's Board of Trustees, in its enlightened support for ICI's entire exhibition program, makes it possible each year for many thousands of people to experience new art and to absorb and confront new ideas: I salute the Board for its generosity and commitment.

Susan Sollins
Executive Director

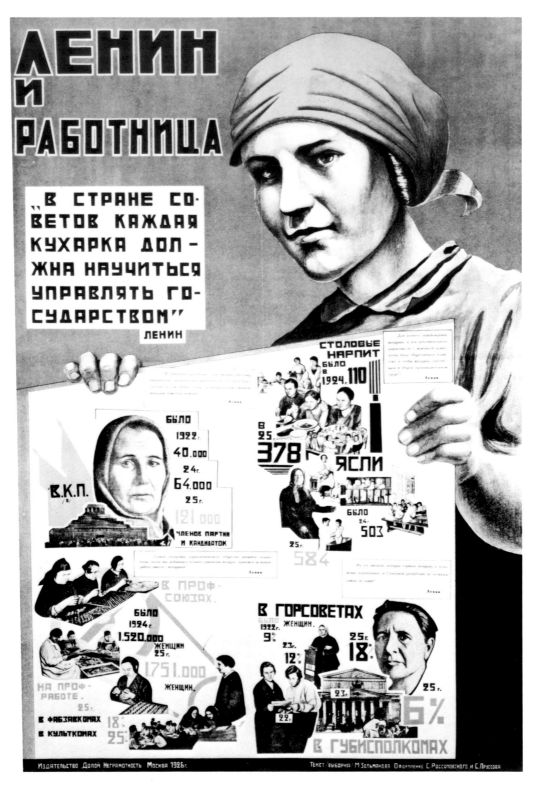

FRONTISPIECE (ARTIST UNKNOWN)
Lenin and the Female Worker (Every Kitchenmaid Must Be Able to Rule the State), c. 1920s. Poster

AFTER PERESTROIKA:
KITCHENMAIDS OR STATESWOMEN

Margarita Tupitsyn

Why are there practically no women among you?
One gets an impression that the Moscow alternative art world
is just as phallocratic as the cultural establishment.

It's because being "alternative artists" is a rare
and dangerous profession. It's like hunting lions.[1]

In some recent Russian art criticism one encounters signs of a disturbing position with respect to the function of the mechanisms of ideology. A number of Moscow critics and artists seem to believe that with the fragmentation of the Soviet paradigm of totality, the notion of ideology per se has ceased to exist and that the reign of pure aesthetics has taken over. Such naiveté entails a number of predictable attitudes. First, this position ignores the powerful presence of many *other* ideologies or, in Frederic Jameson's words, "other techniques of the commodification of the mind."[2] Second, it promotes a long-obsolete belief that aesthetics can manifest itself beyond an ideologized space such as, for example, a gallery or museum. Third, it assures artists that in order to be in the vanguard in Russia today one needs only to shock the new bourgeoisie by such infantile gestures as showing leopards or carving pigs in a gallery space.[3]

The participants in *After Perestroika: Kitchenmaids or Stateswomen*, by contrast, were among the first in Russia to recognize that underneath each ideology there is always another. And in the wake of the dismantling of Soviet doctrine they began to reflect upon the ideology of gender, making the first contributions to its critique and taking the initial steps against the assumed belief in a single ideology.[4]

As the epigraph to this essay suggests, the extreme pressure of officialdom forced Russian alternative artists to cleave together in order to establish their own identity—with a total disregard of all forms of otherness, such as feminism and homosexuality.[5] But with the fall of totalitarianism such a defensive politics of identity became not only outdated but clearly reactionary.

In *Femininity and Domination*, Sandra Lee Bartky writes: "Coming to have a feminist consciousness is the experience of coming to see things about oneself and

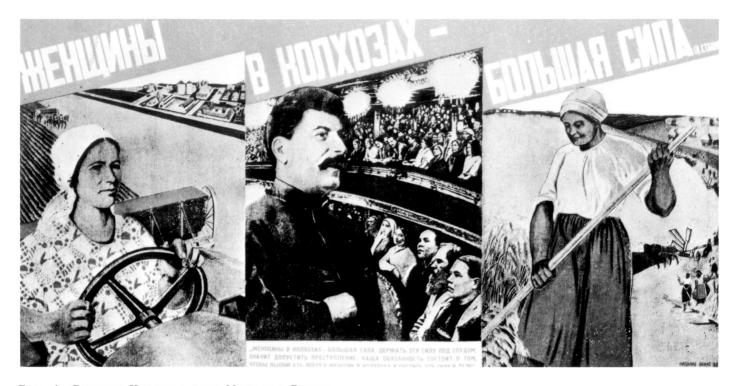

FIG. 1 GUSTAV KLUTSIS AND NATALIA PINUS
Women on Collective Farms are a Substantial Power, 1933. Poster

one's society that were heretofore hidden. This experience, the acquiring of a "raised" consciousness, in spite of its disturbing aspects, is an immeasurable advance over the false consciousness which it replaces."[6] *After Perestroika* is not about women's art so much as it is about the rise of a feminist consciousness such as Bartky describes. This consciousness has surfaced in the perestroika-era work of both male and female artists, who attempt to begin to articulate a theory of socialist patriarchy not unlike the discourse of western feminism on capitalist patriarchy.

Soon after the October Revolution, Lenin commanded that "in the land of the Soviets, every kitchenmaid must be able to rule the state." Yet in 1922 Aleksandra Kollontai observed that "the Soviet state was run by men, and women were to be found only in subordinate positions."[7] Lenin's postulate was widely quoted in propaganda materials, of which an anonymous poster from the mid-1920s, *Lenin and the Female Worker*

(Every Kitchenmaid Must Be Able to Rule the State) (frontispiece), is representative. The poster depicts a smiling, kerchiefed woman with an illustrated chart in her hands. The chart tells the viewer about women's increased roles in various realms of Soviet life. From these statistics one learns that the highest position given to females is party membership; one hardly finds any mention of their role in the Bolshevik government. Other dicta of Lenin included in the chart specifically stress the role of "the second sex" in the productive sector. During the revolutionary period, women were also actively recruited in Soviet campaigns of propaganda and agitation desperately needed due to the grand scale of the new country and the vast uneducated population. But, their position in society, like that of the revolutionary artists (whose art was also used for propaganda purposes), declined drastically by the early 1930s when the Bolsheviks gained a stable power base.

Given this state of affairs, it is not surprising that

one finds the most liberating female images in work of an agitational nature produced at the end of the 1920s and in the early 1930s, primarily in conjunction with the events of the First Five-Year Plan. In order to better serve propaganda needs at that time, most radical Soviet artists shifted to the production of photomontages, posters, and photographs, a large number of which represented women workers involved in efforts to realize Stalin's First Five-Year Plan. Although these mass-produced images advertised working women as the equals of men, they nevertheless fulfilled the condition outlined by Hélène Cixous, who wrote, "When a woman is asked to take part in this representation she is, of course, asked to represent man's desire."[8] In posters like *Lenin and the Female Worker* (Every Kitchenmaid Must Be Able to Rule the State), the leader's rhetoric "asserts the primacy of the masculine

term," and in later Five-Year Plan images, women participate in the representation of Stalin's desire for nationwide industrialization. For example, Gustav Klutsis and Natalia Pinus's poster, *Women on Collective Farms are a Substantial Power* (1933) (fig. 1), shows two female collective farmers, one on a tractor and another mowing, under the patriarchal gaze of Stalin who stands between them. Here the male leader is the ultimate referent of the women's effort and accomplishment. In general, women's place vis-à-vis the leader took on a similarity to the position, in the Christian tradition, of women as Christ's brides. For example, Georgii Zelma's photograph of an Eastern marriage, *In a City Hall* (1925) (fig. 2), in which the bride is traditionally and heavily veiled, and his documentation of a woman dispensing with her veil, *Down with 'Paranja'* (1925) (fig. 3), do not signify a process of liberation

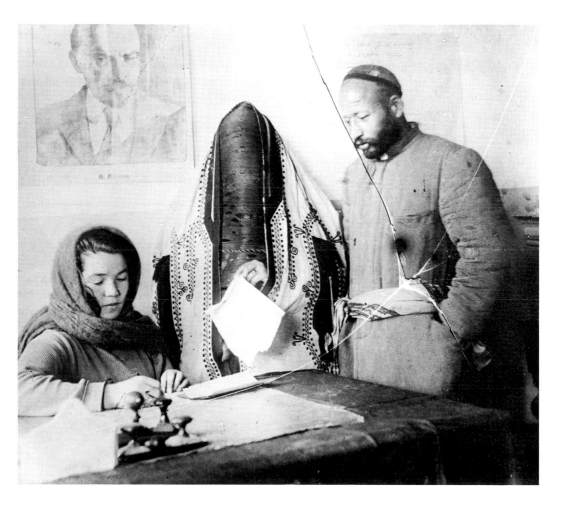

FIG. 2 GEORGII ZELMA
In a City Hall, 1925.
Black-and-white photograph

Fig. 3 Georgii Zelma
Down with 'Paranja', 1925.
Black-and-white photograph

from male ownership but rather a woman's symbolic marriage to an ultimate husband—the leader for whom her face from now on is bared.

Michel Foucault argued that what is "true" depends on who controls discourse, and in the 1930s Stalin's domination of cultural discourse trapped women inside a male "truth." In the period of Socialist Realism, female imagery, like all the genre's other iconographical elements, was subjected to the strictest control and stereotyping. Shown primarily as heroines performing for the collective or as idealized mothers and workers, the Socialist Realist representation of women illustrated them as ultimately happy human beings, unfailingly ready to serve the state's objectives. Such masculine screening of the representation of women in mass culture narrowed women's choices in life and forced them to identify with tightly controlled models of female behavior. Manifestations of feminine weakness were expelled from the pictorial language, except in repre-

sentations of leaders' public appearances, where women could permissibly be depicted as overcome with justified emotion. The politically-charged signification of Socialist Realism's narratives excluded any ambiguity of meaning. Women were shown in a state of emotional uncertainty only in those instances where they were obviously awaiting the return of husbands who were fighting for country and leader.

As a result of this monolithic masculine model of the world, by the time of the thaw during Khrushchev's regime, official and unofficial women artists had inherited what can be called the patriarchal unconscious. Soviet women artists adhered to the idea that, in order to speak, they had to assume a masculine position; thus, almost invariably, they met any attempt to analyze their work from a feminist point of view with unconcealed skepticism or indifference.[9]

Clearly, the negative status of feminism had already been reached, if not caused, because legendary Soviet

feminists such as Kollontai, Nadezhda Krupskaia, and Inessa Armand had been instrumental in the promotion of political propaganda that contributed to the success of Bolshevism's patriarchy and its despotic machine. Hence their feminist ideas provided scant inspiration to the community of post-Stalin female intellectuals who were largely opposed to the government. Moreover, the imposition of communal living inaugurated after the Revolution had corroded the sisterhood among women that existed earlier and led to the creation of the "New Woman" who, because of the adversative atmosphere of communal living (arising from crowded conditions and absence of privacy), often felt compelled to alienate herself from female neighbors.[10] In addition, due to censorship, women in the Soviet Union were deprived of any literature that reflected the discourse and politics of gender as they were developing in the West.

Beginning with propagandistic material produced for the First Five-Year Plan, mass media representations of women's activities oscillated between depictions of joyful labor and images of cheerful motherhood, which stood in sharp contrast to the destructive reality and misery of the communal ghetto that women confronted on a daily basis. Today, when the failure of Soviet propaganda's false promise of feminist utopia is exposed, a number of artists are attempting to unravel the heritage of heroic mass-media imagery and to re-think its meaning and function. Andrei Roiter and Georgii Guryanov search the popular magazines of the Stalin era (which began with the First Five-Year Plan in 1928 and ended in 1953) for mass-media images of women to incorporate in their work. Guryanov re-sexualizes black-and-white photographic compositions of asexual female workers when he duplicates them in vividly colored canvases. He comments on the exclusion of the suggestion of sexuality from the mass-media propaganda portrayals of industrialization that led ultimately to Stalin's self-serving increase of productivity. By contrast, Roiter preserves the grayish aura of old magazine illustrations when he covers photocopies of them with a layer of varnish, or

re-creates on canvas the images borrowed from the fading photographs. In these works, Roiter illustrates how the Soviet establishment continuously produced images that effectively promoted an imaginary social paradise for women's labor and leisure.

Ilya Kabakov, whose installations deal with various aspects of communal living and reflect on "communal mentality," comments on the gender structure within that environment. He explains: "No one [in a communal apartment] hammers nails into boards or repairs faucets, because all these functions are performed by 'it' [the Russian neuter pronoun *ono*]. When a lightbulb burns out or a wallboard in the hallway rots through, the only recourse is to apply to the housing committee."[11] The maintenance board is run by the almighty *ono*, the androgyne, the ultimate Other, responsible for the function (or, rather, disfunction) of Soviet society. The ironic reference to androgyny as an alternative to sexual difference may be explained as the result of the state's treatment of the population as a genderless body without organs; all deviations from this model were unacceptable. The four panels in Kabakov's series *Four Essences: Production, State, Love and Art* (1983) are imitations of the *stengazeta* (the maintenance board's newsletter). Magazine spreads, color plates, postcards, and photographs of all kinds of historical and contemporary significance cover the panels. Quotations from official speeches and poems appropriated from Stalinist rhetoric accompany the images. This is the anonymous production of neither male nor female origin.

Elena Elagina draws the viewers' attention to a neuter (rather than male or female) gender by often naming her works in the neuter. Like Kabakov, she promotes the idea that neither sex is the more powerful in the Soviet Union. The sources of Kabakov's and Elagina's models of androgyny may be found in some representations produced for the First Five-Year Plan, specifically in Klutsis's poster design, *We Will Build Our Own New World* (1929), celebrating the Sixteenth Party Congress, and in El Lissitzky's poster for the *Exhibition*

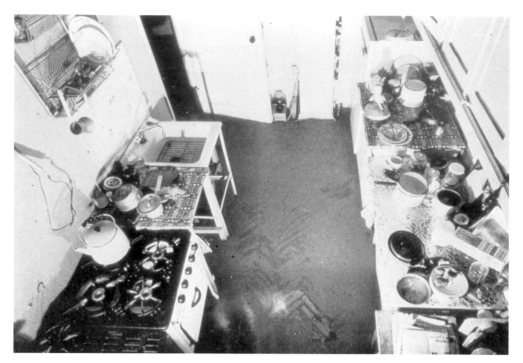

FIG. 4 ILYA KABAKOV
Olga Georgievna, Something is Boiling, 1984. Black-and-white photograph

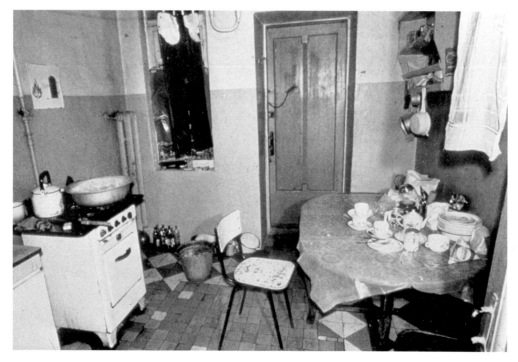

FIG. 5 ILYA KABAKOV
Olga Georgievna, Something is Boiling, 1984. Black-and-white photograph

of Soviet Art (1929) in Zurich. Both show two faces, one male and one female, merging into each other by the sharing of an eye. Such merging of a male and a female into an androgynous or "interindividual" being may be a metaphor for the birth of the "third person" [*ono*] who would run the "New World."

Elagina's installations made of industrial and household paraphernalia suggest that the key to women's liberation and equality with men lies in women's denial of "woman-ness" and in the commitment to arduous work, both at home and in society. Elagina's work comments on the fact that although the reality of Soviet womanhood before perestroika was squalid and lacking in everyday necessities, it was hypocritically promoted in the media as a positive experience.

Larisa Zvezdochetova is drawn to objects taken from the popular culture of her childhood, specifically those found in the decor of the dismal communal apartments of the 1950s and 1960s, including cheap mass-produced carpets, embroideries, and textiles. Placed on the walls of private rooms which separated neighbors in communal apartments, thus removing them from the antagonistic commotion of a shared kitchen, these objects came to embody private fantasies and desires suppressed by the pillory of the "law of the commune." Similarly, Kabakov's *Sign up for the Mona Lisa at Prokhorova's (Room #24)* (1980, not included in this exhibition) takes us beyond the communal corridor into the room where everyone can "sign up" for a separate "reverie" (the image of the Mona Lisa serves as a metaphor of such), and thus be liberated from the oppression of collective aspirations.

Kabakov's folding-screen album, *Olga Georgievna, Something is Boiling* (1984) (figs. 4 and 5), and the Peppers' jars of pickled and preserved fruits and vegetables bring us close to the reality of a communal kitchen. Kabakov records its facts through documentary photographs accompanied by dialogues and chains of narrative. Annoyingly endless phrases uttered by the apartment's tenants refer to the kitchen as the center of interaction, conflicts, and mutual surveillance.[12] The

Peppers' installation with jars of preserved food placed inside typical Soviet slippers turns two common objects into metaphors for gender behavior in the communal kitchen. The slippers symbolize men returning from work only to quietly avoid interaction with other tenants; the jars allude to women returning from work and plunging into the kitchen to realize grand projects of food preservation motivated by fear of future shortages.

The title of Elagina's installation, *PRE* (Wonderful) (1990)—*pre* refers to the adjective *prekrasnoe* (wonderful)—is an ironic expression of women's dissatisfaction with their domestic realities. In this work, consisting of three white letters, two red pots, and a red shelf, Elagina creates a subtle interaction between visual and verbal elements. The literal meaning of *krasnoe*, from which the adjective *prekrasnoe* is formed, is "red." Thus the viewer looking at this installation first reads "*pre*" and then sees red household objects which complete the word "wonderful" through visual rather than verbal means. By means of this clever formal play, Elagina also reminds us of the ideological significance of the color red which, throughout Soviet history, has served as powerful "decor" for official ideology. Elagina's installation announces a woman's uncomfortable feeling about domestic reality by using the interrupted adjective, and resolves that discomfort by introducing the color red, a habitual compensator for all ideological gaps and inconsistencies.

Like Elagina, Maria Serebriakova wants to expose the constantly ignored burdens that stem primarily from chronic shortages in every aspect of women's lives. Serebriakova places pins over subtle drawings of hands making cookies that evoke representations of working hands popular in photographs from the era of the First Five-Year Plan. The joyful spirit of labor, which those historical images attempt to convey, here turns instead into a sado-masochistic impression (conveyed by the pins) of the repetitive rituals of cooking and washing. Serebriakova's drawings and collages which advertise "elegant, convenient, useful" objects to

Soviet women fantasize about women as happy consumers, a status that to this day remains unattainable.

Elagina also collaborates with her husband, Igor Makarevich. Such teamwork between male and female artists has been a convention in Russia since the early twentieth century. At that time the avant-garde artists Natalia Goncharova, Olga Rozanova, and Varvara Stepanova, by collaborating with their husbands, involved them in such traditionally female practices as textile and costume design. After the Revolution, these media (more often than painting and sculpture) symbolized the artist's radical position in society and culture. Interrupted by Stalin's suppression of the politics of gender, this tradition was resurrected during the Khrushchevian thaw of the late 1950s. At that time, collaboration with a man (or having one as a spouse so that he became an automatic supporter of female creativity) seemed to be the first step toward the rebirth of an alternative to Socialist Realist women's practices in art.

Elagina and Makarevich's installation *At the Source of Life* (1991) critiques women's position in the Soviet scientific establishment. It includes a portrait of the Stalin-era biologist Olga Lepishinskaia, framed by two photographs that show women participating in scientific research and school girls learning "true science" from Lepishinskaia. Lepishinskaia's mouth holds a plastic tube, which is connected to a bowl of water placed on a table nearby. By submitting the "mad" scientist herself to a mocking experiment, Elagina and Makarevich comment on the fact that, because science was as politicized as any other sphere of Soviet life, the research produced by people like Lepishinskaia was entirely senseless and served only to satisfy Stalin's infinite hunger for mythologizing.

Like Elagina and Makarevich's installation, the Peppers' *Handkerchief Painting #2* (1991) undercuts the phoniness of Soviet science, which often sacrificed truth for the sake of ideology. Here a female lecturer uses as her object for instruction the Peppers' familiar jar of preserved vegetables covered with a top ornamented by

fake formulas. In other work, the Peppers attack the shocking conditions of Soviet medical practice. For their plywood panels addressing the issues of gynecology, they borrow medical descriptions of various gynecological conditions from outdated scientific books still in use in current medical practice. *Data Concerning Discharge as Related to the Degree of Vaginal Cleanliness According to Hermin* (1989) bears a chart with gynecological data, including descriptions of "exterior appearance of discharge" or "condition of the sexual organ." Enamelware lids cover some parts of the chart and the chart also depicts a grinning and fragmented face. The panel in turn connects to a stool with a hollow in which there is a plastic duck's head. The installation may be viewed as a metaphor for abortion and its devastating effect on Soviet women, who are not only deprived of contraceptives but also subjected to inhuman medical treatment without the benefit of anesthesia.

The Peppers' examination of gynecological issues indirectly brings us to the broader issue of sexuality in Soviet culture. For example, shortly after the Revolution there were liberal laws concerning homosexuality; later, under Stalin's regime, the framework of sexual behavior was strictly defined and any deviations from it were subjected to harsh criticism.[13] Ideologists like Andrei Zhdanov promoted an "antisexual aesthetic," the purging from Soviet culture of signs of sexual deviance and the repression of any public manifestations of "frivolous" behavior that might be in conflict with true revolutionary spirit. An anti-Freudian campaign and a general bashing of psychoanalysis paralleled this attitude.[14] The Victorian echo which reverberates in this anti-sexual politics allows us to assume, as did Foucault, that "if sex is so rigorously repressed, this is because it is incompatible with a general and intensive work imperative."[15] This was indeed the essence of the work ethic imposed by the Communist Party at the time of the great industrialist projects.[16]

Komar and Melamid's *Girl in Front of a Mirror* (1981–82) and Leonid Sokov's *Stalin and Marilyn* (1986)

offer scenarios of what was happening behind the curtain of the anti-sexual campaign. Sokov depicts Stalin and Marilyn Monroe in an amorous embrace, creating a sharp contrast to familiar official representations of the leader as a superhuman who lacked human desires. The work exposes Soviet leaders' secret admiration for Western objects of sexual desire and in general reminds the viewer about incidents of *apparatchiks'* promiscuous behavior that were carefully hidden from the public.[17] Komar and Melamid's *Girl in Front of a Mirror* depicts a Pioneer girl in a uniform who sits in front of a mirror, masturbating. The latter act, presented with Balthusian evasiveness, alludes to the presence of hidden erotic connotations in many Socialist Realist canvases.

Sokov's choice of Marilyn Monroe as the object of desire for the Soviet leader is significant vis-à-vis the representation of female images in Soviet mass culture. Soviet women, whose lives were depleted by the hostile relationships engendered by communal living and by the patriarchal, ideological surveillance of their outside work, often became asexual disciplinarians. Timur Novikov's *Woman with a Whip* (1988) (which is reminiscent of Masoch's Wanda in *Venus in Furs*) communicates his fear as well as ridicule of precisely such a woman. But by executing *Woman with a Whip* in fabric Novikov softens and neutralizes the image of female authority.

Svetlana Kopystiansky, Maria Konstantinova, and Irina Nakhova, as well as Novikov, initiate a discourse on "feminine Otherness." Abigail Solomon-Godeau points out that this discourse "heightens awareness of the radical alienation of women from language and, indeed, from all the symbolic systems in which a culture's reality is represented."[18] Thus these artists attempt to depart from masculine imagery and language, "the 'alien point of view' that women have historically accepted."[19] Novikov explores the femininity of the work of art by giving up traditional tools such as canvas, palette knife, and oil paint. Instead he shops for locally produced textiles, sews various pieces together, and makes subtle drawings or applies photographs on

them. Kopystiansky directs deconstructive strategies toward the annals of Russian literature dominated by male creators. She adopts fragments of various literary texts and inscribes them on pieces of canvas or on landscapes, a favorite genre of the paternalist tradition of Russian culture. She inscribes some of the canvases with writings that she later crumples up, thus obtaining a distortion of the text as a symbol of the masculine power of speech. Furthermore, the crumpling of the canvas contributes to the appearance on it of vaginal folds, which thus begin to absorb and devour the text.

Konstantinova's series of fabric objects provides an example of feminist critique directed at visual icons of Soviet culture. Whether she transforms Kazimir Malevich's landmark painting, *Black Square*, into a cushion in *M. K. K. M.* (1989) (a play on the two artists' initials) or turns a potent, hard-edged Soviet red star into a floppy impotent object in *Rest in Peace* (1989), she points to the end of imperial Soviet thinking and the death of patriarchal authority, whether it arises from aesthetic or political totalitarianism.

For a long time Irina Nakhova was the only woman artist in the male community of conceptual artists. Her shift from painting to installations in 1984 was met by her male colleagues with particular interest. The project consisted of four successive installations placed in her living quarters and called *Rooms*. In each of them Nakhova covered the walls, the ceiling, and the floor with cutouts (ranging from abstract shapes to various reproductions from popular magazines) and changed the lighting to create unexpected visual effects. The idea was to transgress the limits of the two-dimensionality of painting and to place a domestic viewer within the picture in order to expose her or him (so little accustomed to experiences other than verbal ones) to an avalanche of visual information. Ironically, the project acquired a rather different context when the critic Joseph Bakshtein volunteered to guide visitors (without Nakhova's participation) and record their reflections upon the "rooms."[20] However, Bakshtein limited the list of commentators to

twelve male artists, who thus became an integral part of the project's function after its execution. His experiment demonstrated how visual experience can ferment into a chain of narratives and allegorical constructs, proving that the control of Soviet conceptualism's interpretive strategies belonged to "the 'alien point of view'."

Most of the work produced by Nakhova since perestroika responds not so much to specific aspects of Soviet culture as to culture per se. The artist views the latter as a mine of masculine knowledge-production which she dislocates and de-contextualizes. In *Camping* (1990) she skillfully paints classical images of gods and goddesses on the canvas surfaces of worn-out and ripped cots. Here Nakhova undermines the heritage of high culture imagery by clashing it with the low standards of Soviet popular artifacts.

Among the distinguished features of Gorbachev's rule was the fact that, unlike previous leaders, he demonstrated an unusual indifference toward the monuments of his predecessors and instead of erecting new ones glorifying himself,[21] dismantled the Berlin Wall and became involved in the disarmament campaign. As a result, for the first time since the Revolution, a Soviet leader gave up "vertical mental images" and in general avoided the phallocentric path of monument-making of which the most grotesque example is a huge rocket erected near the VDNKh (the Permanent Exhibition of Agricultural and Industrial Achievements) subway station in Moscow. According to Vitaly Komar, this monument (given its explicit phallic shape) is referred to among the population as "the dream of an impotent." Neighboring this rocket is perhaps one of the most famous Soviet monuments—*Worker and Female Collective Farmer*, a sculpture by Vera Mukhina. Like Klutsis's and Lissitzky's double representation of a male and a female mentioned earlier, this work also epitomizes the merging of the two genders—not, however, through their physical fusion but because the male

worker holds aloft a hammer, and the female collective farmer a sickle. In this way Mukhina seems to suggest that differentiation between the two genders would result in the destruction of this prime Soviet icon. Afrika's *Birth of Agent* (1990), a photograph of Mukhina's sculpture printed on textile, alongside a medical drawing of a Caesarean section, announces the end of the Soviet paradigm of gender unification in general and Mukhina's in particular. The Caesarean section is a metaphor of the rather painful birth of a discourse on sexual difference and the proclamation of the voice of the second sex.

Like Afrika's treatment of Mukhina's sculpture, Oleg Vassilyev's two lithographs dismantle the myth of Lenin's slogan, "Every Kitchenmaid Must Be Able to Rule the State." If the anonymous poster of the 1920s discussed earlier possessed an iconographic and semantic clarity, Vassilyev's lithographs are composed from overlaid images and fragments of ideological texts which together create a field of contradictory meanings. These works testify to the gross failure of Lenin's assumption that women can be only kitchenmaids or stateswomen. This enforced viewing of official positions as the high point of achievement, and the relegation of the kitchen to the bottom of the hierarchy, forcefully predetermined the destiny of women in the Soviet Union and programmed every female to strive toward goals established by the state.

Vladislav Mamyshev's impersonation of Marilyn Monroe (fig. 6) is the most radical attack of conventional images of masculinity and femininity in Soviet culture. In his performances he employs Monroe's character not as an object of desire but as a metaphor for the weakness of his male identity. As he strolls through St. Petersburg's streets and squares in a female outfit and a wig, he performs shock therapy on the communal body of a Soviet population whose static mental images of gender roles have resisted change since the Bolsheviks defined them after the Revolution.

Ever since perestroika, the majority of Russian women still fail to recognize that they suffer domestic and/or political oppression. This makes it difficult to convert them into partisans of a feminist course. Even if we accept their claim to political and domestic equality, it is possible, as Sandra Lee Bartky reminds us, to be oppressed "in ways that need involve neither physical deprivation, legal inequality, nor economic exploitation; one can be oppressed psychologically. The psychologically oppressed become their own oppressors."[22] This is precisely what happened to Soviet women before perestroika, and it is still the case today: they are unwilling to acknowledge manifestations of psychological oppression (which include stereotyping, cultural domination, and sexual objectification), and so they continue to serve as "their own oppressors."

Events at recent exhibitions dedicated to women's art reflect the lack of serious consideration given to women's issues by the majority of Russian men. For example, during *Visitation*, in March 1991, the male curator and some male artists decided to participate in the exhibition under female surnames, thus confusing and diminishing the issues of feminism at hand.[23] This was once again proof of a refusal to acknowledge the difference between and separation of men and women, and proof, too, of a continued "merging" and "fusing" of genders which has become the symbol of failed Soviet feminism. On a broader level, this gesture profoundly illustrated the failure of most Russian intellectuals to recognize the multiplicity of ideologies beyond the old Soviet doctrine.[24] ✶

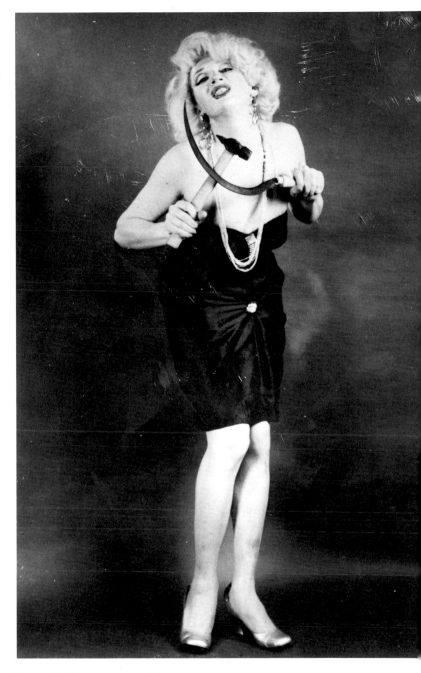

FIG. 6 VLADISLAV MAMYSHEV
Documentation of performance entitled
Marilyn Monroe in Moscow, 1990

1 Such was my question to the members of the Aptart movement and their response. Quoted in Margarita and Victor Tupitsyn, "The Studios on Furmanny Lane in Moscow," *Flash Art*, no. 142, October 1988, p. 103. When I first returned to Moscow in 1987, I was disturbed by both male and female artists' lack of interest and irritation at gender issues. For a discussion of that period, see Margarita and Victor Tupitsyn, "Six Months in Moscow," *Flash Art*, no. 148, October 1989, pp. 115–17, as well as my "Unveiling Feminism," *Arts Magazine*, December 1990, pp. 63–67.

2 Frederic Jameson, *The Ideologies of Theory: Essays 1971–1986*, Volume 2: *The Syntax of History* (Minneapolis: University of Minnesota Press, 1988), p. 47.

3 These two events took place at the Regina Gallery in 1991 in Moscow and became the most provocative and controversial events in the local art world.

4 The male artists—Komar and Melamid and Sokov—participating in this exhibition do not necessarily hold progressive views on the gender issue. Their work, however, deals with a kind of representation which permits exposure of critical issues of feminist discourse.

5 The concept of unofficial or alternative art came about at the end of the 1950s when a very small group of artists began to work in styles other than Socialist Realism. For further discussion of the history of alternative Soviet art see my *Margins of Soviet Art: Socialist Realism to the Present* (Milan: Giancarlo Politi Editore, 1989).

6 Sandra Lee Bartky, *Femininity and Domination* (New York: Routledge, 1990), p. 21.

7 Richard Stites, *The Women's Liberation Movement in Russia* (Princeton: Princeton University Press, 1978), p. 327.

8 Quoted in Craig Owens, "The Discourse of Others: Feminists and Postmodernists," in *The Anti–Aesthetic: Essays on Postmodern Culture*, ed. Hal Foster (Port Townsend, Washington: Bay Press, 1983), p. 75.

9 This position surfaces in various statements by contemporary Soviet female artists who maintain that art is a male profession and who seem to regard themselves more as men than women, or at least as some version of St. Thomas Aquinas's "imperfect man."

10 Because of the prolonged period of communal living experienced in the 20th century by Soviet citizens, there is no equivalent in the Russian language for the English word "privacy."

11 Victor Tupitsyn, "From the Communal Kitchen: A Conversation with Ilya Kabakov," *Arts Magazine*, October 1991, p. 52.

12 Kabakov's mother's letters, which were exhibited as part of the installation *He Lost His Mind, Undressed, Ran Away Naked*, present an important document of the life of a single mother (Kabakov's father was killed during the Second World War).

13 According to Timur Novikov, before Stalin's regime Soviet marriage bureaus registered couples of the same sex. He claims that a Soviet encyclopedia of the period explained that since "in bourgeois countries (and in Russia before the Revolution) homosexuals and lesbians suffered and were very unhappy people, so in our country all the necessary conditions for living were created for them." Quoted from Victor and Margarita Tupitsyn, "Timur and Afrika," *Flash Art*, no. 151, March/April 1990, p. 123.

14 It is interesting that until recently the Soviet intelligentsia treated psychoanalysis with great suspicion primarily because of its association with Freud. Thus one can say that the official bashing of psychoanalysis had an impact even on alternative communities.

15 Michel Foucault, *The History of Sexuality*, trans. Robert Hurley (New York: Vintage Books, 1980), p. 6.

16 Victor and Margarita Tupitsyn, "Timur and Afrika," p. 123. Curiously, Afrika suggests that such strict control of sexual behavior "gave birth to 'peculiar' forms of sexuality. One person expressed his sexual attraction to another person by reporting him to the authorities, thereby (sadistically) condemning the object of his affections to suffering. This was a form of satisfaction." Afrika's suggestions may help to explain why so many people "enjoyed" acting as informers.

17 There are many stories about the outrageous behavior of Soviet *apparatchiks*. One of them describes how Lavrentii Beria (Stalin's chief of the KGB) ordered girls he saw passing by his window to be brought to him.

18 Abigail Solomon-Godeau, *Photography at the Dock: Essays on Photographic History, Institutions and Practices* (Minneapolis: University of Minnesota Press, (1991), p. 239.

19 Ibid.

20 These were later documented in a self-published book, *Rooms*, compiled by the Moscow Noma (conceptual circle) in 1985. In the book the artists discuss and document with photographs various issues surrounding their living and working conditions.

21 This was noted by Vitaly Komar during an informal lecture in his studio in 1992 about Soviet public sculpture.

22 Bartky, *Femininity and Domination*, p. 22.

23 Another exhibition, *Hearts of the Four* (fig. 7), took place in the summer of 1992. Once again the event was more of a playful nature than an attempt to analyze gender issues. It is curious that the most serious exhibition of women's art was the first one, *Female Worker*, in the fall of 1990. This was organized by the participants themselves, without a male curator.

24 After I wrote this essay in December 1992 I went to Moscow thinking that the issues that I explored in it would by now be widely familiar in the art world. To my great surprise and discontent, however, I discovered that the state of affairs as far as "a feminist consciousness" is concerned has deteriorated in comparison to that of Gorbachev's era. At that time the complete dismantling of official and unofficial structures and hierarchy allowed women to believe that their voices could finally acquire larger presence. After the coup, however, when new institutions began to be formed, women were once again dismissed to the peripheral positions, the most popular of which is serving tea at men's meetings and discussions of artistic affairs.

Another aspect of the Russian art world which struck me greatly was a continuous unwillingness on the part of most men and women alike to clean up language of most common sexist comments and expressions. Even female artists who had lived in the West for a while would allow themselves to say something like "why didn't he ask the girls [who work for him] to take care of this matter?" Perhaps the most telling comment as far as the present status of women in society is concerned was a statement which I heard from one working woman. She said, "Russian women have learned how to do everything except how to resist men."

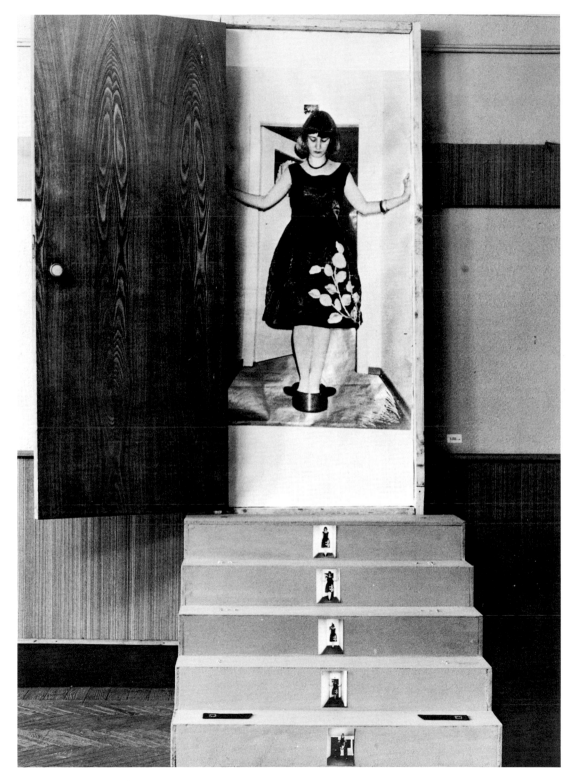

FIG. 7 MARIA CHUIKOVA

The Scale of Ranks. Installation at *Hearts of the Four* exhibition, summer 1992, Moscow

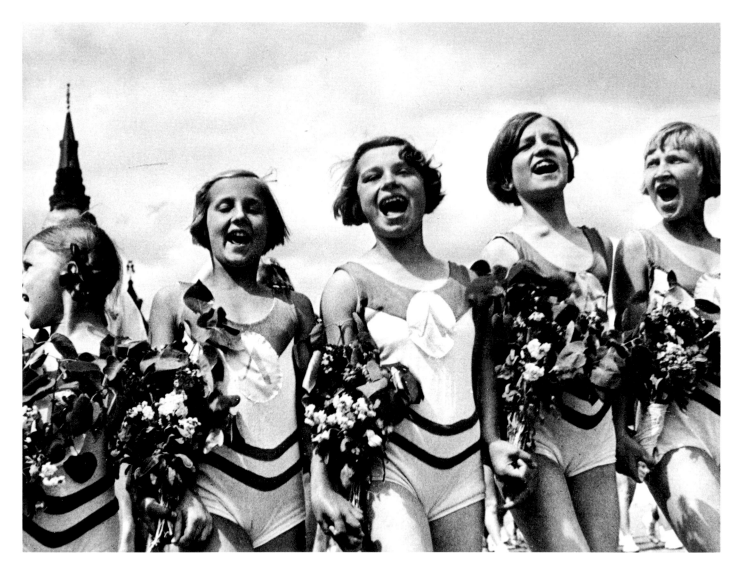

GEORGII ZELMA

Sport Parade, 1931. Black-and-white photograph, reprint from a vintage negative, 8 ½ × 10 ¾ inches

Some Observations on
Women as Subjects in Russia

Martha Rosler

In the summer of 1992 I spent a bit more than a month in Russia.[1] Most of the time was spent on a riverboat on the Volga with about 150 Russian photographers (members of the Russian Union of Art Photographers)[2], a dozen Americans, and a few Europeans, mostly photographers. We engaged in formal and informal discussions of photography, aided by translators of varying skill.

The Americans on the boat fell into two groups: the Easterners, who were up on current art and photo theory and practice, and the Southwesterners, most of whom were not. One of the knowledgeable Southwesterners, Martha Casanave, tried to explain to the Russians in clear and careful lectures the meaning of representations of women, particularly those that depict women as passive and enervated. Her efforts were poorly understood; indeed, when any of us attempted to explain our work, we met with blank incomprehension. Likewise, when the Russians offered explanations of their work, beyond the obvious, I could only dimly discern what they had in mind. Despite these problems, we saw a great deal of work during the boat trip and had many long discussions. My comments here are based on those experiences and on some general observations.

Perceptions of Soviet Art in the United States

I begin with the refractory lenses through which we, in the United States, view Soviet art and photography. Once upon a time in the West—not very long ago—we considered state-approved art as an instrumental element of the Soviet propaganda apparatus and, therefore, of no further interest to us. We regarded dissident art, what little we saw, as a half-strangled cry for freedom of the individual against the state, or as an expression of the rage or irony of the dispossessed (as in the case of the emigré writer Alexander Solzhenitsyn or the emigré painters Komar and Melamid). As for the work of the early revolutionary period, we took it—after the period had ended—as a bittersweet outpouring of hope and optimism from naive, deeply deluded artists and photographers—just as artists are always reckoned to be naive and deluded about social facts when they presume to intervene in issues of social justice. Thus, *soi-disant* discerning Western scholars and connoisseurs of advanced culture "rescued" the Constructivist work of Rodchenko, Stepanova, Tatlin, Klutsis, Eisenstein, and even Vertov, from the withering wrath of the commissars. But this material was in most instances ideologically positioned as the work of "Byronic" visionaries unwittingly immolating themselves on the pyre of the Revolution.

Since the Western intelligentsia, made up of writers, artists, and photographers (including myself), specializes in individual expression, we could be relied upon to deplore the rule of the art commissars. In cold-war America, we viewed Soviet dissident visual art as perhaps aesthetically stunted, distorted by the lack of a free exchange of ideas, but applauded it as authentic nonetheless. As a symbolically laden *cri de coeur*, it was above ordinary judgment. And a requisite characteristic

was its scarcity. What use is dissident art if it consists of more than just a few precious examples? As to Russian photography (apart from Second World War images, such as those made by Dimitri Baltermants), as far as the West was concerned, Russian photography was done by the French photographer Cartier-Bresson![3]

After the End of the Cold War

Following the collapse of the cold-war system of world alignments, many former Soviet artists and photographers, cast onto their own resources like most other former Soviet citizens, have been scrambling to make a living in the free-for-all. They display a broad range of approaches. Some are interested in self-expression; others hope to develop a Russian or more local style. Still others pursue commercial success, photojournalistic success, or international recognition. As one Russian photographer remarked, the goods are in Russia, but the money is in the West.[4] Many, hoping for a market in the United States, expressed surprise at the minuscule percentage of artists who actually make a living from their work. Nevertheless, the question of paramount concern is whether there remains any interest in the West in Russian work per se, now that the political enemy and its official culture has disappeared.

The pre-modern or early modern attitudes toward art that I encountered in Russia appeared to be holdovers from the period in which art did not circulate freely. There is a revived interest in pictorialism, long outdated in the West—an interest not so different from the current Russian interest in the Orthodox Church. Both, as indigenous, pre-Soviet cultural expressions, are taken as manifestations of an essential "Russianness." This interest in Russian identity may be ominous, since national essentialism, including reactionary Slavophilism, has often provided an excuse in Russia for social exclusion, ranging from anti-Semitism and other religious persecutions to genocide. Less

weightily, *fin de siècle* pictorialism was the last movement in which the aim of photographers was to appear to be numbered with the artists rather than regarded simply as manipulators of mechanical apparatuses.

Despite the search for true expression of the "Russian soul,"[5] ex-Soviet photographers are familiar with the famous practitioners of Western photography and have been influenced by them to varying degrees. Many deny such influences, out of a desire for personal originality or national authenticity that may or may not conflict with a desire for international recognition and financial reward. The English cultural theorist Stuart Hall suggests that the search for a national or ethnic identity represents a contradictory movement. On the one hand, it is a look backward to a mythical historical moment when ethnically pure national identities existed. On the other hand, a people's wish to describe a national identity may represent a muffled hope that nationhood will provide entrée to the Western European community and its markets. It is a building block in the formation of a larger geographic identity that is consensual rather than repressively imposed.

Bodily Symbols

Along with nationalism, individualism appears to be on the post-Soviet agenda. All over the East Bloc, as the social strictures of state socialism have melted away, images of the body have repeatedly been the focus of expressions of a private life and even of the formerly disapprobated individualism. This is as true of bohemian subcultures as it is of mass culture. We may surmise that the persistent representation of nudity represents an objective correlative, or exteriorization, of feeling states related to a newly discerned realm of personal freedom. But two other observations need to be added. One is that the bodies represented are, by and large, women's bodies. The other is that the manner of their representation follows various well-traveled routes of

eroticization. Here, for the purpose of argument, I consider only heterosexual representation. Heterosexual pornography (pictures or stories of women in sexual poses or acts, with a presumed audience of men), previously forbidden under Soviet regimes, is now widely available in Russia. Playboy-style images that we associate with men's locker rooms or working-class, male-dominated shops have appeared in unlikely public places: in large, attendant-run women's bathrooms in train terminals in the Russian interior; in taxis; on bus drivers' glass-walled enclosures; and in other spheres captured by males, such as the operating booths at amusement parks.

Why Women? (If It Needs Explaining)

Women's bodies are centrally positioned symbolic elements in the newly constituted realm of desire in Russia and the East Bloc, partly because advertising (in which American agencies still corner the world market) insists that it is so, because the great majority of photographers are men, and because the great majority of women have been rendered economically redundant by the changes in the former Soviet Union.

In the newly emerging, still quasi-anarchic market-oriented conditions in the East Bloc, massive unemployment is affecting women disproportionately. If state socialism required full employment, even if accompanied by absurdly low levels of productivity, capitalism requires a reserve army of labor to discipline the labor force. Women form a significant component of the classical reserves. Three years ago, in 1990, 92 percent of Soviet women worked or studied full time; women constituted 51 percent of the labor force. Now, in 1993, women constitute 70 percent of the registered unemployed, who number at least four million. Two years ago the average Soviet woman's wage was 70 percent of the average man's; now, according to Deputy Prime Minister Vladimir Shumeiko, it is 40 percent and falling

fast.[6] The West vacillates between shoring up the post-Soviet economy by supporting viable industries and offering income support to its people, on the one hand, and simply plundering its resources, including raw materials and skilled labor, on the other. Russia is experiencing a "brain drain" as millions rush to obtain exit visas. Most of the emigrés, the scientists and skilled workers, are men (and their families). By and large, women must seek other options.

Aside from Western press boosterism for entrepreneurial endeavors, there has been very little press coverage of post-Soviet social conditions, or of daily life. In the United States, only left-of-center publications—including the *Nation*, the now-defunct *Guardian*, *Monthly Review*, and *In These Times*—have paid attention to actual economic and political realities in the former Soviet Union, and to women in particular. Journalist Fred Weir reports that Russian Labor Minister Gennady Melikyan told stunned Western journalists: "Why should we employ women when men are unemployed? It's better that men work and women take care of children and do the housework. I don't want women to be offended, but I seriously don't think women should work while men are doing nothing. Russia is the only country that has so many working women."[7]

Feminist writer Elvira Novikova told Weir, "Our economy is collapsing. Poverty has engulfed the majority of our people, and it's impossible for most families to live even on two salaries. In this context, women are being commanded to sacrifice themselves, to give up all their rights, hopes, and claims and willingly accept permanent serfdom as their lot."[8] Many of the women who have lost their jobs are middle-aged and highly educated. Vera Soboleva, coordinator of international projects for the Women's Union (successor to the communist women's organization), says that engineers, academic researchers, and administrators who are looking for jobs are offered work as computer operators or hairdressers, jobs in child care and domestic services, or

home labor, such as taking in laundry or sewing. Younger women, looking for jobs as secretaries, clerks, or salespeople in new businesses, face intense sexual harrassment.[9]

The process of the dis-employment of women also seems to reflect their political disenfranchisement. In the East Bloc, women have been relegated to the partly imaginary private sphere—whose real tasks they haven't in any case managed to escape responsibility for.[10] In Poland, women's reproductive choices have been bartered away to the Catholic Church, although most of the population, and even most Polish legislators, according to polls "don't believe" that abortion should be banned or criminalized. Poland offers other examples that may well speak to the future of the former Soviet Union—for example, the clear emergence of a comprador class of the very rich, who live and consume, as the *New York Times* says, next door to the newly poor.[11]

Also relevant to the present discussion are the remarks of a Polish publisher in 1991 at a Harvard symposium on censorship. This man, founder in the mid-1970s of the first of many small illegal presses that published dissident works, was told by the Catholic Church that he, like others, must now publish pornography to survive.[12] What liberation from state tyranny has brought Poland and the rest of the East Bloc, including the former Soviet states, is pornography and religion. Religion[13] tells people what to think about—or to fear—and pornography tells them what to desire. Religion and pornography together effectively establish an internalized patriarchal reordering of society, in which both men and women voluntarily take on familiar, differentiated roles. It is difficult to escape the connection between the omnipresent reminders of women's "use" as sex objects and the idea that women live in the bedroom, not the boardroom. Pornography and advertising securely position women as domestic appliances, while men are their possessors. Otherwise,

women are chaste madonnas. The familiar distinction between the virgin and the whore has been reinscribed in the fabric of society and in people's consciousnesses, with the footnote that even the whore is granted a social status superior to that of the unattached, independent woman. Russian enthusiasm for the Orthodox Church, the omnipresent wearing of crosses and display of icons, is part of a resurgence of nationalism that no doubt reflects a desire to find a new authority for life direction, if it is not a passing fancy.[14]

All over the East Bloc, religion and pornography—and prostitution—are likely to continue to coexist. But pornography is not made with slaves chained to the camera. If women had better or at least more varied social prospects before the present revolution, why are they now willing to adopt these poses before the camera? The answer is partly economic. If we take pornography to be a branch of the commodified sex industry, of the apparatuses of eroticism as a product of mass culture, then the women who work in this industry are sex workers of a sort. What is at issue here is that economic conditions drive many women to enter the sex industry without enthusiasm and with a good deal of shame. This represents a waste of the social talent and motivation that are essential to other sectors of society and constitutes an internal form of brain drain.

There is also a social element that accounts for women's willingness to participate in the production of subservient images. Soviet social policy was productivist in the extreme. The state granted little importance to the sphere of social reproduction, as opposed to social production. Since social reproduction remained women's sphere, women's needs were most obviously neglected. Thus, sanitary napkins were unavailable; birth control was surgical; perinatal care had deteriorated with the economy; housing and household labor were neglected. Furthermore, for various reasons, the Soviet state, after initial liberalizations, returned to strongly supporting the institution of mar-

riage, making it particularly imperative for women since it was otherwise difficult to obtain social supports and benefits of any kind.[15]

According to Elvira Novikova, positive post-Soviet media presentations of women show them primarily as sex objects—as beauty contest winners, brides of rich men, and sometimes even as prostitutes. The emphasis is on material rewards. The second most likely category of women to be presented positively is that of successful businesswomen, but they too are described in terms of their clothes, possessions, and leisure activities. Third are women who become nuns! Working women, on the other hand, are presented as "public enemy number one."

Feminism, however, attracts very few Russian women at present. On the one hand, the popular mind in Russia, as in most of the world, associates feminism with lesbianism. On the other hand, as Carla Lipsig-Mummé writes, "for both men and women…, pride in the admirable efforts of the Soviet regime to provide day care, to educate women well, to open job categories, etc., blocks recognition of the continued, pervasive inequality of women in the home, the family, and the double day of work."[16] Feminism no doubt suggests a wish for disconnection from family and society, motives with which Russian women do not identify.

As a class, women in the Soviet period were relegated to poorly rewarded jobs,[17] performed a significant proportion of menial labor, and had little social power. Today they have become avid consumers of images of Western glamour, of glamourpusses living lives of ease with men at their feet. Many women seem anxious to adopt the masquerade donned around the world by women seeking economic protectors. The masquerade includes not only the sexualized look of women on the make—constructed of makeup, short tight skirts, stilleto heels, and pouts—but also the ambiguously masculinized dress-for-success costume of women in business. Many Soviet state employees wore uniforms, but noth-ing about the attire suggested femininity except the skirt, and facial makeup was unlikely. Now it seems required. Ads for ordinary jobs for women often openly require thin, young, and pretty women "without complexes"[18]—i.e., sexually docile or compliant—although this runs contrary to the Soviet guidelines still in place.

Women's impulse to explore the contents of a sphere of femininity is understandable and even necessary. The desexualization of Soviet society—if that is the cause—has led to conditions causing women to express sexual dissatisfaction in safe settings. Femininity, if nothing else, seems patently linked to sexual desire, to a sexual identity.[19] It doesn't matter that the bodies Russian women must now seek are attainable by perhaps five percent of the population. The new images Russian women seek to embrace mean leisure, they mean power: the face they want is the power face; the body they want is the power body. Femininity seems also to offer women a chance to escape insecurity—it promises a new longed-for realm of freedom: freedom from wage slavery or worse, unemployment; the freedom not to work but to be taken care of. Routes to social power will be followed even if those in more comfortable social circumstances do not approve.

The fact that such promises are illusory for most women ("the dreams of shopgirls") is of no moment whatsoever. Nor does it matter that gender-role differentiation seems to mean that men corner the market on arrogance and women on self-loathing; it is safe to say that the attitudes of most Russians are already innocent of twentieth-century gender theorizing. And perhaps women are hoping for the sexual satisfaction all but promised women consumers by the Western media and advertising. One wishes, however, that the course being followed did not seem so familiar, so outdated, so mapped out in advance by marketers and market forces and by gender politics in which fetishism (as Freud pointed out) requires crippling along with the worship it engenders. ★

1 I participated in the trip thanks to an exchange between Rutgers University and the Russian Union of Art Photographers.

2 Photography was not supported by the Soviet state the way that art and literature were. The union is a new, post-Soviet organization, very few of whose members have achieved international reputations or sales, although a number wish to do so. Many participants in the trip were working photojournalists, some were part-time photographers, and some were untutored hobbyists, but some of the most important work shown came from those with nonphotographic jobs.

3 Cartier-Bresson published *The Russians*, a book that appeared in the 1950s.

4 Interestingly, he described a system of cultural imperialism, without either seeming to realize that he was doing so or criticizing it. He claimed that all the best photographic work in South America and elsewhere is bought in the United States and that, therefore, Russian photographers only had to continue what they were doing—and the best work would find its way here.

5 A phrase one hears repeatedly, applied to Russia, or Georgia, or any other nationality in the former Soviet Union.

6 Fred Weir, "The Kitchen Revolution," *In These Times*, 22 March 1993, p. 23.

7 Ibid., p. 22.

8 Ibid.

9 Ibid., p. 23.

10 The wife of one of the union's officers, an urban planner whose English was good enough to allow her to do some translating for us, became quite ill during the trip with a respiratory infection. She said, with quite good humor, that she had become ill on her vacation because she couldn't normally afford to be sick, taking time away from trying to get money and food—juggling several jobs, shopping, cooking, and taking care of her husband and two children.

11 The *New York Times* has had occasional articles on the subject. Also see Ann Snitow, *The Nation*, 26 April 1993. Barbara Suchowa, a former Solidarity supporter now rewarded with a cabinet ministry, recently told workers that they must accept the new reality. They used to be of central importance to society but now their position has moved well down the social ladder. The *Times* recently reported that alcohol consumption—an indicator used in the West to measure psychological alienation under communism—has risen significantly in Poland since communism's fall.

12 When the time came to publish the symposium proceedings, the Polish publisher evidently thought better of his remarks. His comments disappeared in favor of a dark warning about the excessive power of the Church and its ability to prevent publication of (i.e., to censor) "sensitive" material. It should be emphasized that this man was—or had been—a Church supporter.

13 Of course, I am referring to the patriarchal religions of the West.

14 Religious enthusiasts must overlook the fact that the church under communism was widely held to be corrupt. During our trip, the most frequent land destination was a church or a cathedral. Almost all had scaffolding around their exteriors, as the gold on the distinctive onion domes was being restored. No trips to mosques or synagogues were scheduled.

15 See Ekaterina Alexandrovna, "Why Soviet Women Want to Get Married," in Tatyana Mamonova, ed., *Women and Russia* (Boston: Beacon Press, 1984), pp. 31ff. Alexandrovna explains how administrative pressures replaced traditional morality and dictated a situation in which being married—no matter how one conducted one's life—was equated with "moral stability." This produced a situation in which divorce was better than never marrying, but in which officials could not divorce without hurting their careers. The state thus encouraged extramarital affairs while officially condemning them. Women were encouraged to have children, even out of wedlock, but were stigmatized or penalized (primarily financially) for having illegitimate children. In some periods, illegitimate fathers had no responsibility for the upkeep of their children. Strong state support for the traditional family together with almost universal female employment meant women were bound to work the "double day," bearing both work and family responsibilities.

16 Carla Lipsig-Mummé, "Russia Between the Union and the Commonwealth: New Carpetbaggers and Old Dreams," *Monthly Review*, June 1992, p. 35. The author is director of the Center for Research on Work and Society at York University in Toronto, Canada.

17 Though not as uniformly low-paying or low-status as those available to them at present.

18 Weir, "The Kitchen Revolution."

19 Obviously, sexuality was far from absent in Soviet life, but the discourse about it was quite shrunken, one might say mummified, and ideas of female satisfaction evidently were not developed.

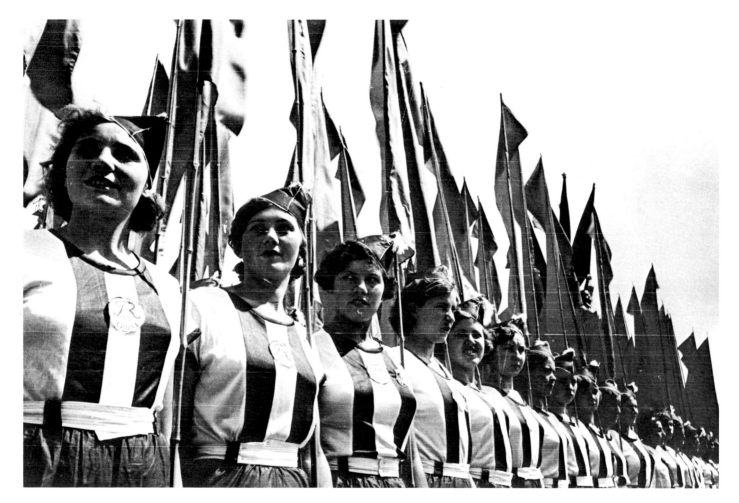

GEORGII PETRUSOV

Sport Parade, 1930. Black-and-white photograph, reprint from a vintage negative, 7½ × 11 inches

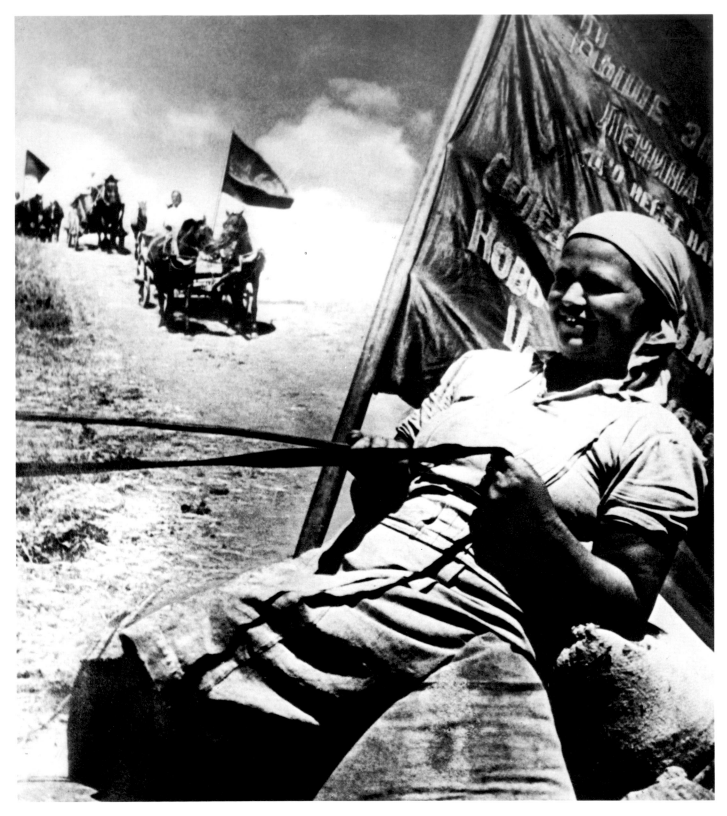

ARKADII SHISHKIN

Let's Give Bread Harvest on Time, 1935. Black-and-white photograph, reprint from a vintage negative, 9 ½ × 8 ¾ inches

PLATES

AFRIKA
(Sergei Bugaev)

★

Birth of Agent, 1990
Photographic textile
116 × 93 inches

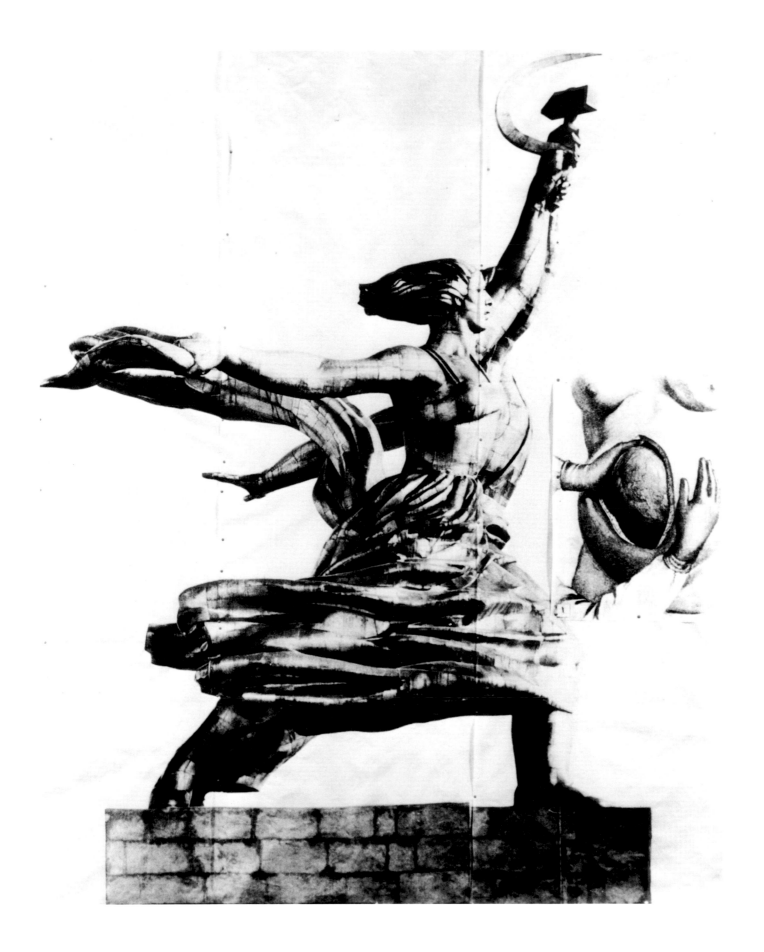

ELENA ELAGINA

*

PRE (Wonderful), 1990
Installation with cooking pans
23 ½ × 74 × 8 inches

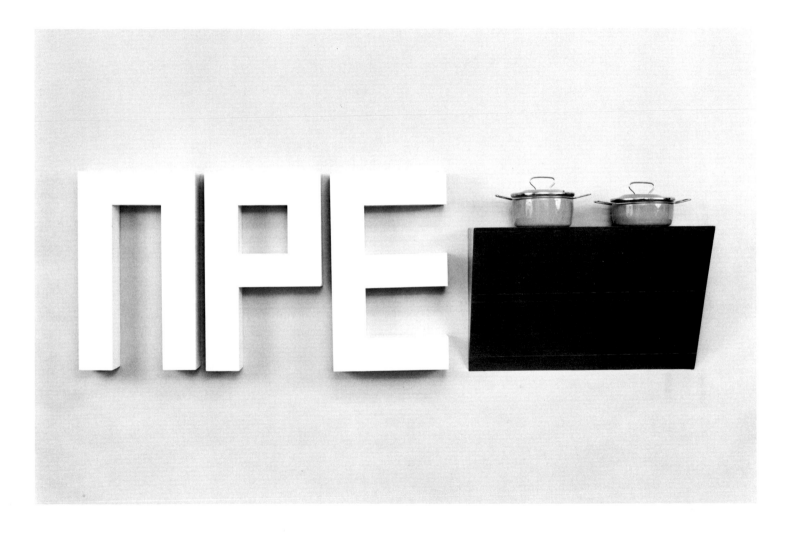

Georgii Guryanov

★

Tractor Woman, 1989
Oil on canvas
65 × 35 inches

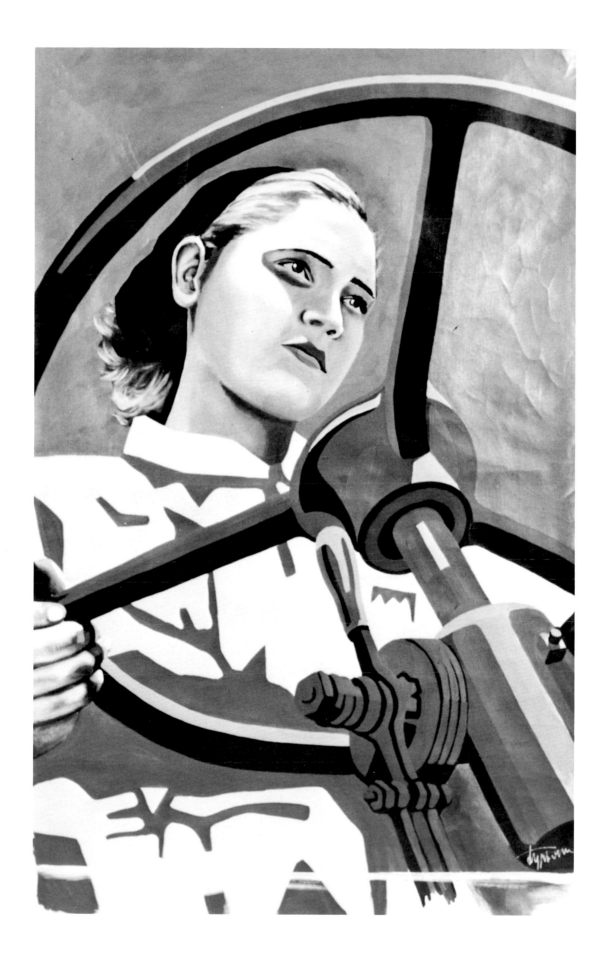

ILYA KABAKOV

✷

Sign up for the Mona Lisa at Prokhorova's (Room #24), 1980
Enamel on masonite
74 3/4 × 102 3/8 inches
(not included in this exhibition)

Запись на „Джоконду"
у Прохоровой Л.С. (комн. 24)

VITALY KOMAR AND ALEXANDER MELAMID

★

Girl in Front of a Mirror, 1981–82
Oil on canvas
72 × 50 inches

MARIA KONSTANTINOVA

✳

M. K. K. M., 1989
Mixed-media installation
27 × 27 × 10 inches

SVETLANA KOPYSTIANSKY

★

Story, 1988
Fabric
25 × 18 × 3 ¼ inches

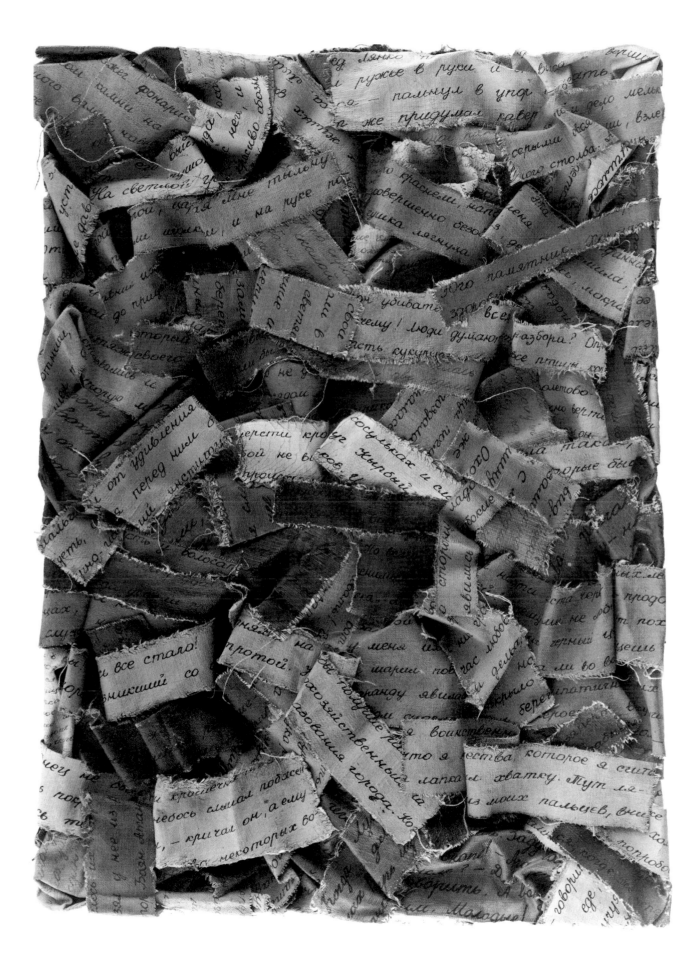

IRINA NAKHOVA

★

Camping (detail), 1990
Installation, oil on canvas cots
$9 \times 28\,^{1}\!/_{2} \times 78$ inches each

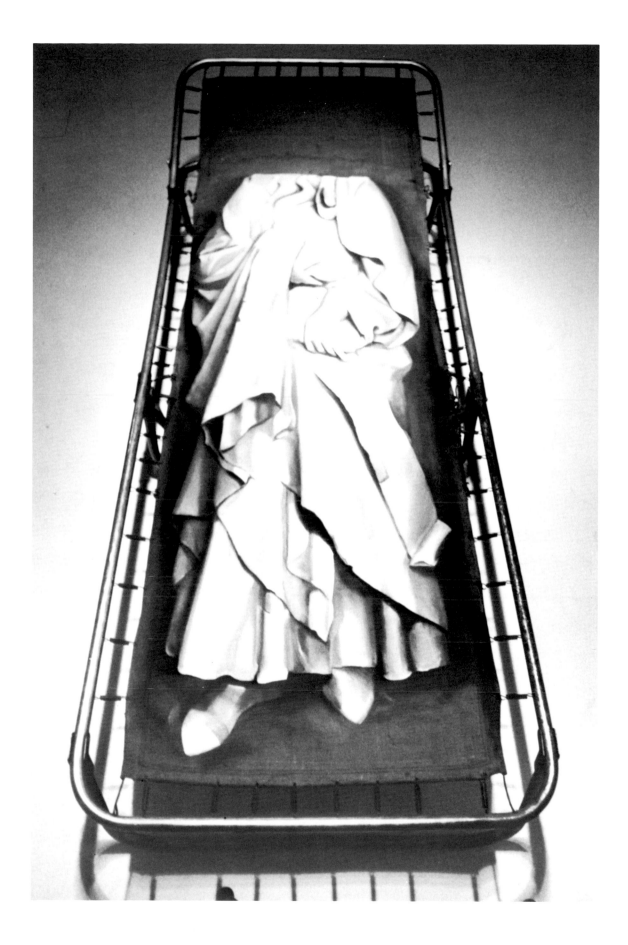

TIMUR NOVIKOV

★

Woman with a Whip, 1988
Acrylic on fabric
67 × 62 inches

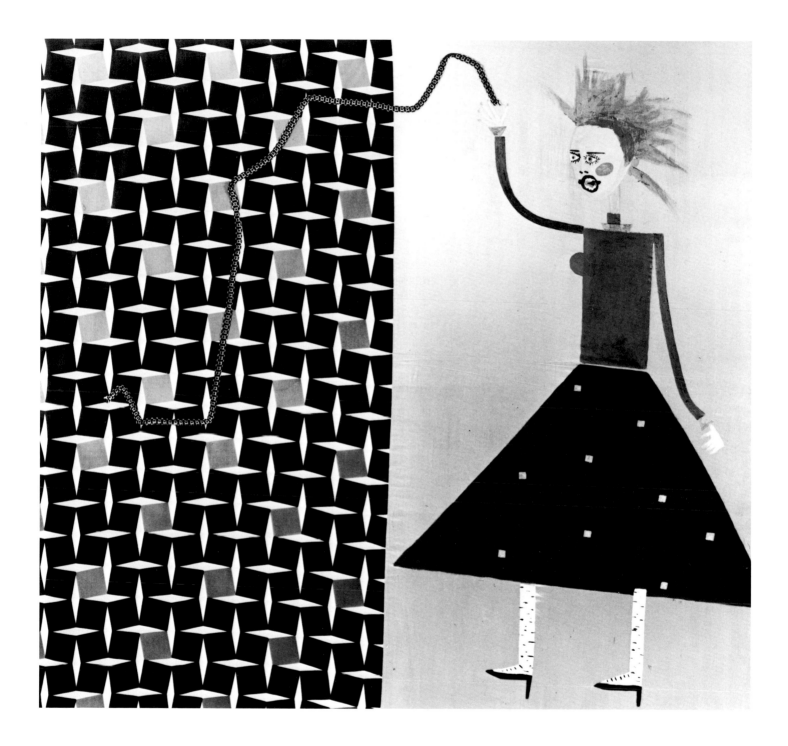

The Peppers

★

Untitled, 1991
Slippers, preserved vegetables, pen lights
4 parts, 11 ½ × 5 inches each

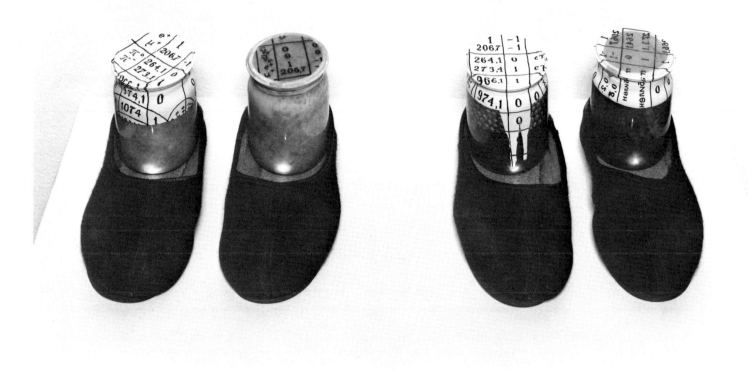

Andrei Roiter

★

Doctor, 1991
Photocopy on canvas
12 × 16 inches

Maria Serebriakova

*

Untitled, 1988
Mixed media on paper
10 ½ × 7 ½ inches

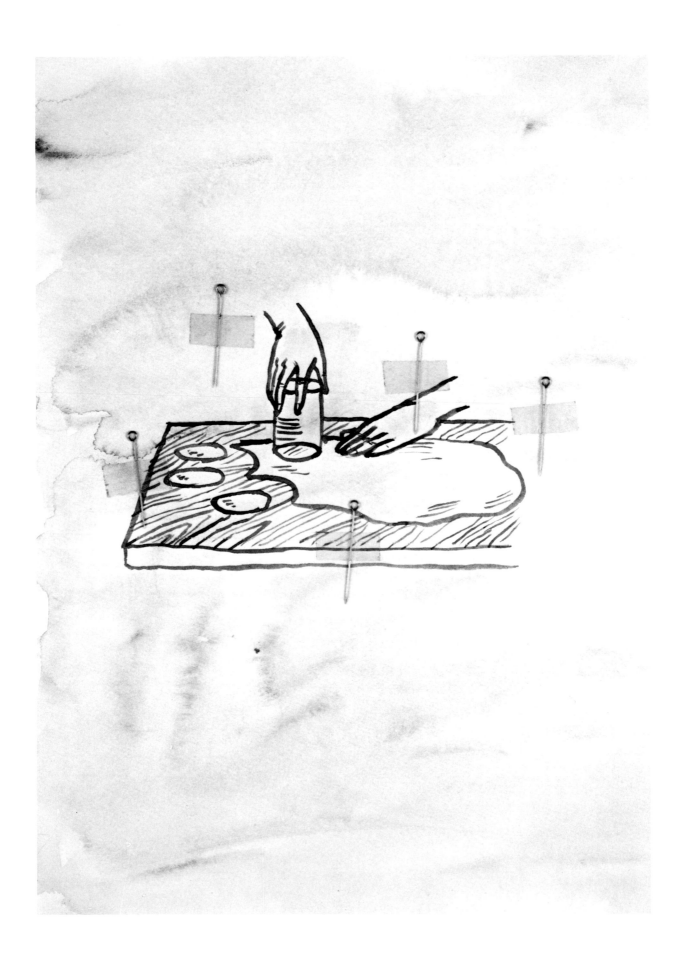

LEONID SOKOV

★

Stalin and Marilyn, 1986
Painted metal
28 × 23 inches

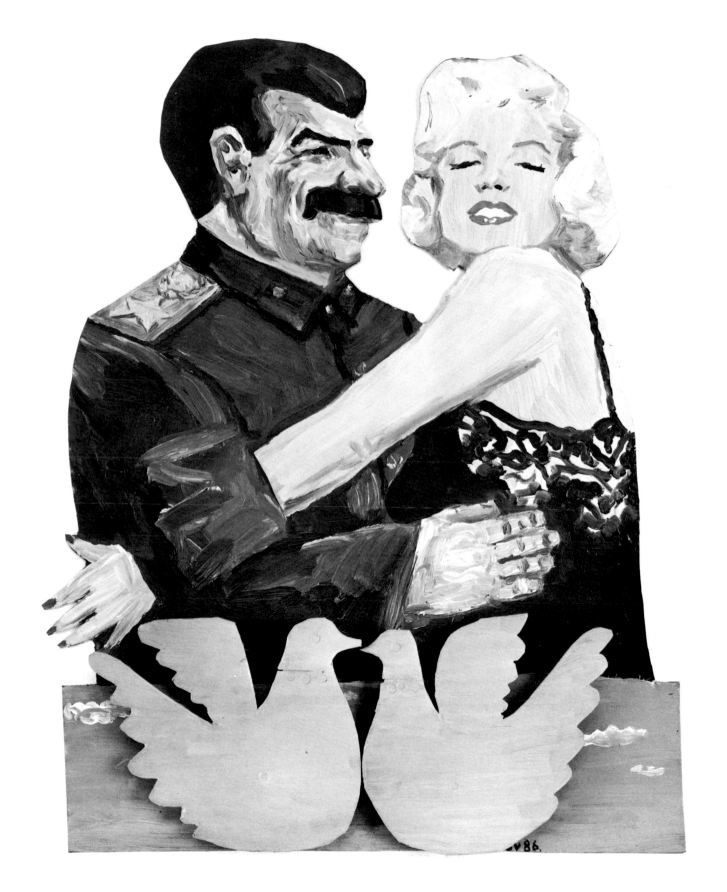

Oleg Vassilyev

✶

Every Kitchenmaid Must Be Able to Rule the State, 1990
Lithograph
29 ½ × 21 inches

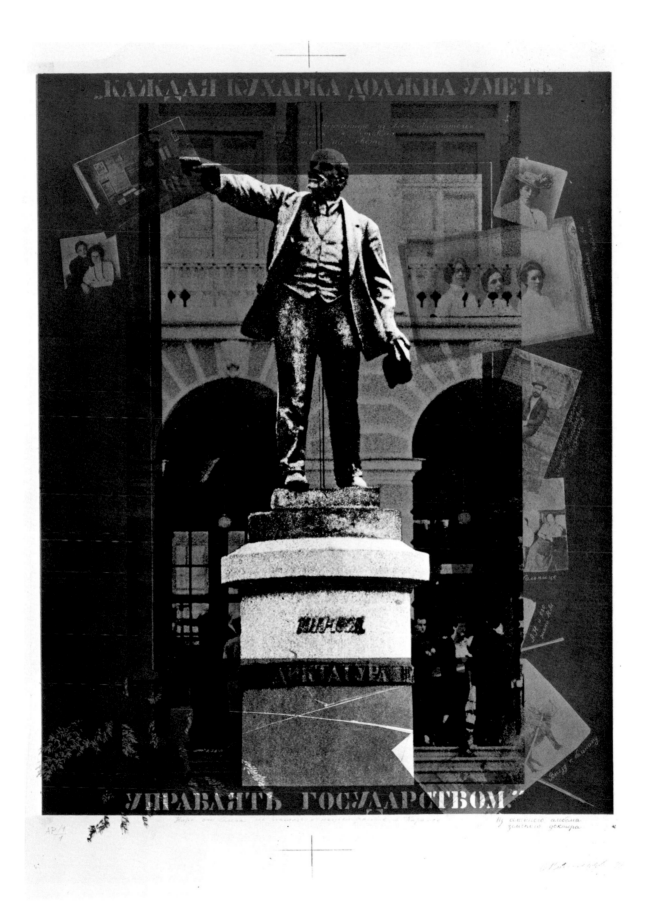

LARISA ZVEZDOCHETOVA

★

VDNKh USSR: Friendship of the Peoples' Fountain, 1989
Mixed media on carpet
49 1/2 × 81 inches

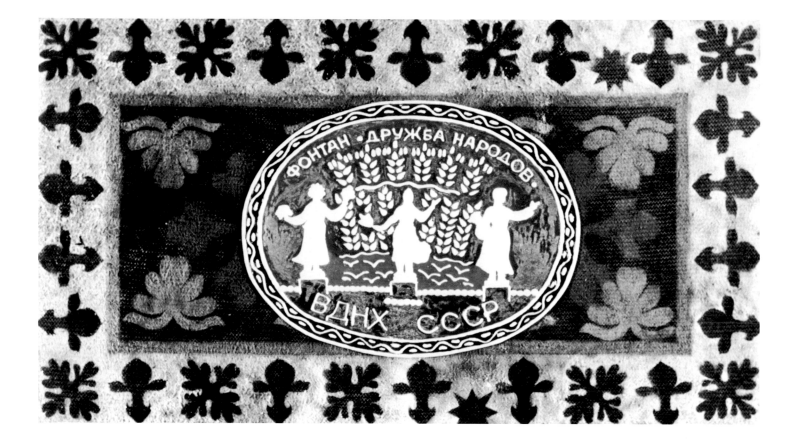

CHECKLIST

(Height precedes width precedes depth)

AFRIKA
(Sergei Bugaev)
Born: 1966, Novorossiisk
Resides: St. Petersburg

Untitled, 1991
Acrylic on photo textile
60 × 119 inches
Courtesy Paul Judelson Arts,
New York

Birth of Agent, 1990
Photographic textile
116 × 93 inches
Courtesy Paul Judelson Arts,
New York

ELENA ELAGINA
Born: 1949, Moscow
Resides: Moscow

PRE (Wonderful), 1990
Installation with cooking pans
23 ½ × 74 × 8 inches
Courtesy the artist

**ELENA ELAGINA AND
IGOR MAKAREVICH**
Elena Elagina
Born: 1949, Moscow
Resides: Moscow

Igor Makarevich
Born: 1943, Tbilisi
Resides: Moscow

At the Source of Life, 1990
Mixed-media installation
Dimensions variable
Courtesy the artists

GEORGII GURYANOV
Born: 1961, Leningrad
Resides: St. Petersburg

Tractor Woman, 1989
Oil on canvas
65 × 35 inches
Courtesy Paul Judelson Arts,
New York

ILYA KABAKOV
Born: 1933, Dnepropetrovsk
Resides: New York, New York

There is Still a Woman..., 1981–88
Oil on masonite
45 × 80 inches
Courtesy Ronald Feldman
Fine Arts, New York

Love, 1983
From the series, *Four Essences*
Enamel on masonite and
postcards
60 × 87 inches
Courtesy Ronald Feldman
Fine Arts, New York

**VITALY KOMAR AND
ALEXANDER MELAMID**
Vitaly Komar
Born: 1943, Moscow
Resides: New York, New York

Alexander Melamid
Born: 1945, Moscow
Resides: Jersey City, New Jersey

Red Drapes, 1984–85
Mixed media
13 ½ × 51 ¾ inches
Collection Richard Ekstract

Girl in Front of a Mirror, 1981–82
Oil on canvas
72 × 50 inches
Collection Raymond J. Learsy

MARIA KONSTANTINOVA
Born: 1955, Moscow
Resides: Moscow

Rest in Peace, 1989
Mixed–media installation
60 × 60 × 40 inches
Courtesy Phyllis Kind Gallery,
New York

M. K. K. M., 1989
Mixed-media installation
27 × 27 × 10 inches
Courtesy Phyllis Kind Gallery,
New York

SVETLANA KOPYSTIANSKY
Born: 1950, Voronezh
Resides: Berlin

Story, 1988
Fabric
25 × 18 × 3 ¼ inches
Collection John Stewart

Story, 1990
Oil on canvas
78 × 103 inches
Courtesy the artist

IRINA NAKHOVA
Born: 1955, Moscow
Resides: Moscow and New York,
New York

Camping, 1990
Installation, oil on canvas cots
9 × 28 ½ × 78 inches each
Courtesy Phyllis Kind Gallery,
New York

TIMUR NOVIKOV
Born: 1958, Leningrad
Resides: St. Petersburg

Woman with a Whip, 1988
Acrylic on fabric
67 × 62 inches
Courtesy Paul Judelson Arts,
New York

THE PEPPERS
(Ludmila Skripkina and
Oleg Petrenko)

Ludmila Skripkina
Born: 1965, Odessa
Resides: Moscow

Oleg Petrenko
Born: 1964, Odessa
Resides: Moscow

Untitled, 1991
Slippers, preserved vegetables,
pen lights
4 parts, 11 ½ × 5 inches each
Courtesy Ronald Feldman
Fine Arts, New York

Handkerchief Painting #2, 1991
Acrylic on cloth
13 ¾ × 12 ¾ inches
Courtesy Ronald Feldman
Fine Arts, New York

Handkerchief #3, 1991
Acrylic on cloth
11 × 9 ¾ inches
Courtesy Ronald Feldman
Fine Arts, New York

*Data Concerning Discharge as
Related to the Degree of Vaginal
Cleanliness According to Hermin*,
1989
Mixed-media installation
Painting: 48 ½ × 58 ½ inches
Wood stool: 18 × 13 × 13 inches
Courtesy Ronald Feldman
Fine Arts, New York

ANDREI ROITER
Born: 1960, Moscow
Resides: Amsterdam and Moscow

t° Silence #1, 1990
Mixed media on canvas
8 1/4 × 15 3/4 inches
Courtesy Phyllis Kind Gallery,
New York

t° Silence #2, 1990
Mixed media on canvas
12 × 12 inches
Courtesy Phyllis Kind Gallery,
New York

t° Silence #4, 1990
Mixed media on canvas
13 3/4 × 10 inches
Courtesy Phyllis Kind Gallery,
New York

Girls, 1991
Acrylic on tarpaulin
102 × 120 inches
Courtesy the artist and
Galerie Johan Jonker, Amsterdam

Doctor, 1991
Photocopy on canvas
12 × 16 inches
Courtesy the artist and
Galerie Johan Jonker, Amsterdam

MARIA SEREBRIAKOVA
Born: 1965, Moscow
Resides: Moscow and Hamburg

Untitled, 1988
Mixed media on paper
10 1/4 × 7 3/4 inches
Courtesy the artist

Untitled, 1988
Mixed media on paper
10 × 7 1/2 inches
Courtesy the artist

Untitled, 1988
Mixed media on paper
8 × 10 1/4 inches
Courtesy the artist

Untitled, 1988
Mixed media on paper
11 × 8 inches
Courtesy the artist

Untitled, 1988
Mixed media on paper
10 1/2 × 7 1/2 inches
Courtesy the artist

Untitled, 1988
Mixed media on paper
8 1/4 × 9 inches
Courtesy the artist

Untitled, 1988
Mixed media on paper
11 1/4 × 8 inches
Courtesy the artist

Untitled, 1988
Collage
16 1/2 × 11 3/4 inches
Courtesy the artist

Untitled, 1989
Collage
11 3/4 × 16 1/2 inches
Courtesy the artist

Untitled, 1989
Collage
17 1/2 × 12 inches
Courtesy the artist

*Elegant, Comfortable,
Profitable*, 1989
Gouache on paper
8 × 11 3/4 inches
Courtesy the artist

*Elegant, Comfortable,
Profitable*, 1989
Gouache on paper
8 × 11 3/4 inches
Courtesy the artist

LEONID SOKOV
Born: 1941, Kalinin
Resides: New York, New York

Stalin and Marilyn, 1986
Painted metal
28 × 23 inches
Collection James Wagman and
Anne Landsman

OLEG VASSILYEV
Born: 1931, Moscow
Resides: Moscow

*Every Kitchenmaid Must Be Able to
Rule the State*, 1990
Lithograph
29 1/2 × 21 inches
Courtesy the artist

*Every Kitchenmaid Must Be Able to
Rule the State*, 1990
Lithograph
29 1/2 × 21 Inches
Courtesy the artist

LARISA ZVEZDOCHETOVA
Born: 1958, Odessa
Resides: Moscow

Embroidery Imitation Landscape,
1989
Mixed media on canvas
48 × 79 inches
Courtesy Krings-Ernst Galerie,
Cologne

*VDNKh USSR: Friendship of the
Peoples' Fountain*, 1989
Mixed media on carpet
49 1/2 × 81 inches
Courtesy Ludwig Forum für
Internationale Kunst, Aachen

REPRODUCTION CREDITS
In addition to all other copyrights
and reservations pertaining to
works published in this catalogue
and held by living artists, their
estates, publications, and/or foun-
dations, and in addition to the pho-
tographers and the sources of
photographic material other than
those indicated in the captions the
following is mentioned:

Sergei Borisov: 19
Courtesy Margarita Tupitsyn: 2, 22,
29, 30, 64
Dennis Cowley: 39, 51
D. James Dee: 41
Georgii Kizevalter: 14
Igor Makarevich: 21
Oren Slor: 35, 55, 57, 59

Editorial Consultant:
Marybeth Sollins

Design and typography:
Russell Hassell

Lithography:
The Studley Press

Limited edition of 2000

Library of Congress Catalogue
Card Number: 93–077562
ISBN: 0–916365–38–7

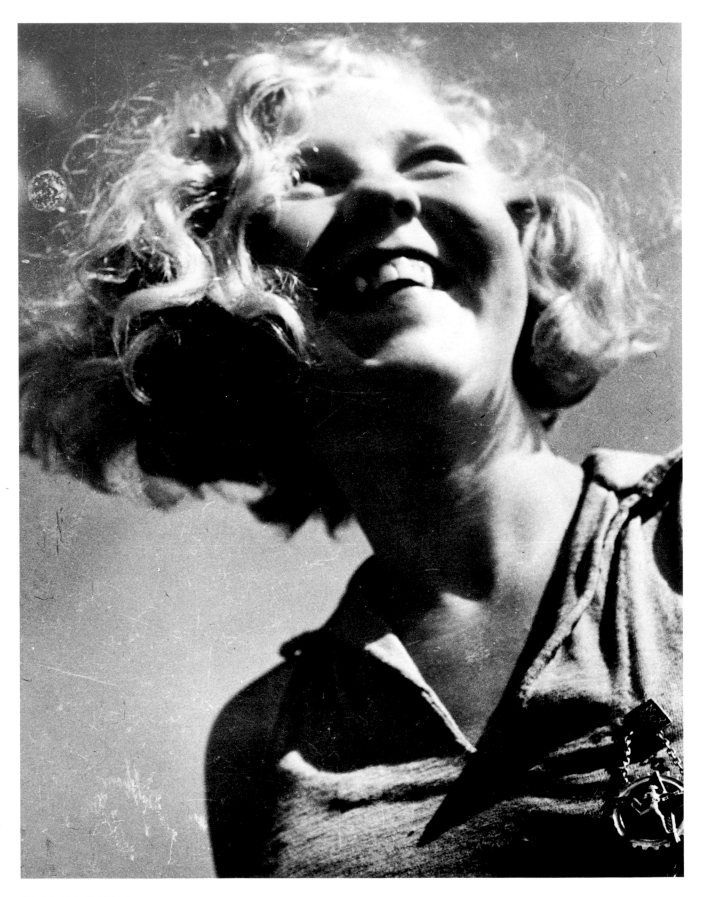

GEORGII ZELMA

The Athlete of the 1930s, 1932. Black-and-white photograph, 11 ¼ × 9 ½ inches